Still Waters

Still Waters

Ava M Lanes, Author and Photographer

For Ava's blog subscription and website access:
www.heritagegalleryandframe.com

Published by Tablo

Table of Contents

Preface

When I began to write this book, one of my initial thoughts was "the voice of calm waters somehow speaks to my soul." Thus, the reason for the title of this book ... "Still Waters." When I was growing up, my family owned a small plot of land in western North Dakota. That land had a small stream/river running through it. I spent, and my family spent, many an hour and many a day on the banks of the Cedar River engaging in water activities (i.e. wading, swimming, rafting, fishing, catching minnows, and skipping rocks, etc.). However, my fondest memory has always been the sight of the calm waters in the evening, as dusk creeped into the end of the day and the fireflies began to light up the darkness. And then it was not only about the stillness, but the combination of the sounds (i.e. crickets, the running brook, the small fish splashing in the water) paired with the visual sights (i.e. the reflections on the water as the moon peeked over the prairie; the green light elicited by those fireflies; the lit, bobbing corks at the end of our fishing poles) and, finally, the undisturbed, emotional feelings that came over me. There, along the banks of the Cedar River, a sense of tranquility fed my soul and gave me a deep appreciation for "Still Waters."

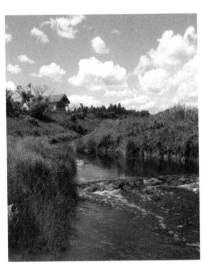

The Cedar River: Still Waters

Take A Walk With Me: To Still Waters

Walk silently, slowly and softly with me ... to still waters. Grounding, also known as earthing, is defined as the electrical energy that can be absorbed through your feet, when you walk barefoot, especially on wet or moist sand. This scientific theory of grounding is believed by many to have a viable health benefit. However, whether you believe in this theory or not, few people would disagree that turning off your cellphone, taking off your socks/shoes and letting your toes move gives one a strange sense of relief and freedom. So take a walk with me and get "electrified."

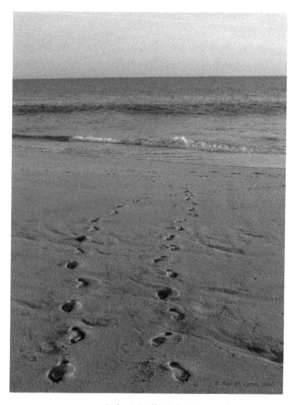

Take A Walk With Me

Pondering And Penning

Take A Walk With Me

The Art Of Reflection: In Still Waters

When we think about reflection(s), what first comes to mind is "self-reflection." But there is power in the art of reflection "of others." There is something sweet about sitting down and writing an actual note or letter to another. In today's world, communication through emails, social media, and text messaging is commonplace. Receiving a handwritten, personalized note touches our emotions in a way that instant communications cannot. Research says it can actually make you happier. Steve Toepfer from Kent State University studies "author benefits" – the perks you get from penning letters. Toepher says by making a habit of writing thoughtful letters of gratitude, "you'll feel happier, you'll feel more satisfied, and if you're suffering from depressive symptoms, your symptoms will decrease." This isn't as strange as it sounds. Telling your family and friends how much you appreciate them helps you count your blessings and notice some of the beauty in your life. It confirms the importance of a relationship. And another astounding benefit? Many, many people save and cherish those handwritten notes …. forever! Yes, write reflections for yourself but do it equally "for others."

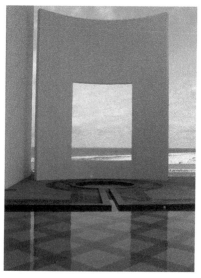

The Art of Reflection

Pondering And Penning

The Art Of Reflection

Seeing Color: In Still Waters

When light hits an object or water - the object or water absorbs light and reflects. Which colors you see depend on the properties of wavelengths and "the what" you are peering at. Seeing color is one thing, feeling color is another! The **power of color** is inescapable. **Color** affects your behavior, moods, and thoughts. A certain **color** has the ability to soothe your frazzled nerves, to agitate a hostile adversary, motivate and empower you to take action, and also to bring healing energy when you need it. It can also be a source of information. While an individual's response to color can stem from personal experience, the science of color, along with color psychology, supports the idea there's far more to it. Countless studies have been conducted related to color, particularly in the areas of marketing and branding. Here is just one high-powered example: Color influences 85% of shoppers' purchase decisions. What colors influence you? What colors seem to effect your moods? Do you have a favorite color and why? What colors make you feel "calm" or "still?"

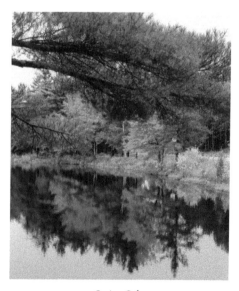

Seeing Color

Pondering And Penning

Seeing Color

Plant Your Umbrella: Close To Still Waters

Like the word "parasol," which is a combination of the French words "parare" and "sol" to mean "shield from the sun," the **umbrella** was originally used to give oneself shade from the heat of the sun. Some days we just need to shield ourselves from the sun, shield ourselves from the crowds and plant our umbrella …. close to still waters …. and breathe. Planting yourself beside an ocean or skipping a rock along an unruffled lake brings inevitable awareness of one's surroundings. It's all about catching a break from the fast-paced rhythm of our modern lives, Nichols writes in Blue Mind. While people do experience a range of emotions by an ocean or lake, many cite the way water, weather and sound interact to produce an overwhelming sense of mental tranquility. There's a reason you feel so at peace when you go near a body of water. Science continues to look at the marvelous healing power that being around water and/or watching the water has on our mental health and wellbeing. I say, plant your umbrella and breathe……

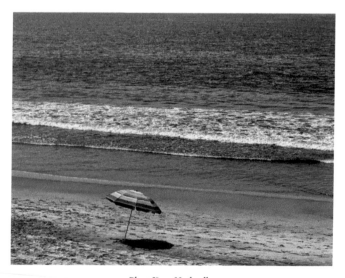

Plant Your Umbrella

Pondering And Penning

Plant Your Umbrella

Bridge To A Better Place: Across Still Waters

As a **metaphor**, a **bridge** between people enables the passage of ideas, it connects people who are in different places, it enables us to be connected, it opens up the opportunity for people to be helped, it reduces isolation, it is a more efficient way of getting to another point, and it increases the range of options. I've come to note, through observation, how people feel about bridges. People love to walk and jog across bridges and many a time you even witness marriage proposals on bridges. Fishermen often have their regular spots staked out and people love to hop out of their cars during bridge openings to enjoy the weather. What do bridges symbolize to people? In the Tarot, the bridge card means progress, connections, and stability. Often people view bridges as the only way to reach a destination and therefore bridges are a way to overcome obstacles. Perhaps my favorite bridge symbol, though, is that of hope. If you can just get over that bridge, you may find yourself in a better place on the other side. Some bridges are harder to cross than others. So, in some ways, bridges can represent a challenge, but challenges with the prospect of better things on the horizon. I find that inspiring and a message of hope of a bridge to a better place, across still waters.

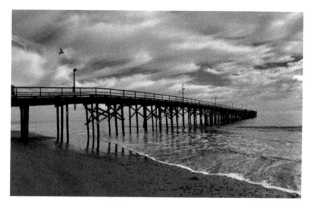

Bridge To A Better Place

Pondering And Penning

Bridge To A Better Place

Glisten: In Still Waters

Glisten, by its very definition, is an adjective that means "to reflect a sparkling light or a faint intermittent glow." One day, while on an ocean cruise, I wondered out to the deck for a breath of fresh air and was intrigued with the sparkling and flickering of the water's surface; it was almost as if someone had lit up the entire body of water with a match. My eyes came to a sudden halt and I stood still as if frozen in time. What a breathtaking sight!! You, too, can glisten. Believe in your abilities. Sure, your friends and family and coworkers might tell you you're great, that you're a shining star, but you won't really believe it until YOU know who you are and that you like who you are. It's as simple as that. Believing in yourself is the first step to being the glistening, shining, and confident person I know you can be!!!! Light the match and glisten, not only on the surface, but from the inside out!!!

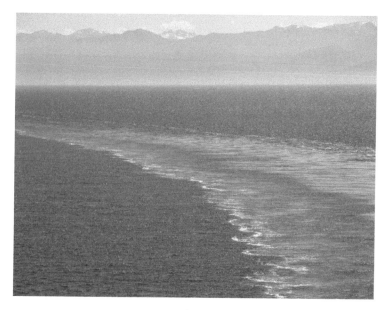

Glisten

Pondering And Penning

Glisten

Your Panoramic Views: Of Still Waters

The beauty of a "Still Waters" panoramic view is that it is so very extensive, so unbroken and expands in all directions. The word 'panorama', of Greek origin, is the result of combining two words pan (all encompassing) and horama (view), signifying "all view", "all seeing." Panoramas are often viewed as powerful and, in some ways, are spectacular visual entertainment. Take time and partake in this visual entertainment. Begin in the middle and gaze to the far left and then to the far right. Each person who takes the time to do this visual contemplation "sees" and "describes" (if you take the time to journal) very different details, attributes and elements. Thus, YOUR panoramic view and YOUR penning is distinctive to you. Just for the fun of it, share your penning of panoramas with another. You will soon discover "your panoramic view of still waters" is uniquely yours.

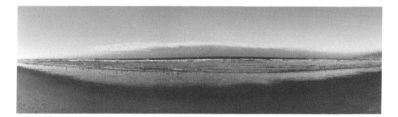

Your Panoramic Views

Pondering And Penning

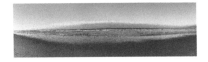

Your Panoramic Views

Face It Head On: In Still Waters

I have had dreams of being a photographer and artist almost all of my life. No matter where life's pathways took me, I always seemed to return to the joys of, and the art of, "seeing" and of "inspiration." In a recent blog, I quoted Ralph Hattersley who stated "We are making photographs to understand what our lives mean to us." One day while on a guided boat trip in Portugal, I saw the profile of a face along still waters. It was on that day, surrounded by those waters, that I decided I would begin to compile my photographs and synchronize them with the written word. And then I thought …. if I can, through these two modes of expression bring inspiration to others, I will have re-imagined my life's dream. And now, if the truth be known, *and almost magically*, I feel as if I have a new-found purpose in my life. So I am convinced that dreams can and do become realities when you face them head on. What do you need to realize? What is your guiding light? What creative force(s) need to be awakened? Have you found your purpose? What do you need to face head on?

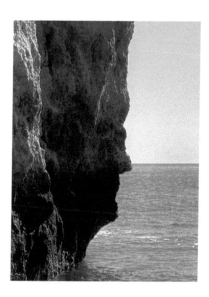

Face It Head On

Pondering And Penning

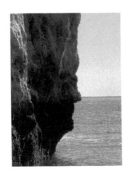

Face It Head On

Broaden Your View: Of Still Waters

Believe it or not, the broader our perspective, the more truth we realize, the more we reduce our ignorance, and the more we enrich our lives. So expand your world views, your experiences, and your opinions as much as possible. Listen when people speak rather than waiting to talk. Give your opinions, engage in dialogue, and revise your perspectives. Seek out people with different backgrounds and opinions than yours. Choose humility. Elevate gratitude. Discipline your mindset. Admit when you are wrong. Be expansive. And be free to grow. Make it a goal to broaden your view!

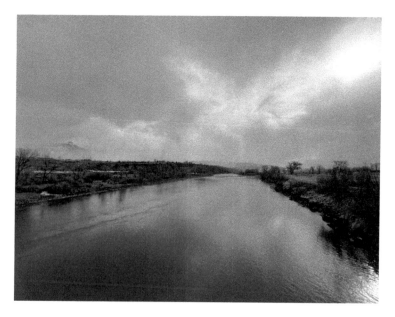

Broaden Your View

Pondering And Penning

Broaden Your View

Open Up: To Still Waters

Open communication requires courage and commitment. Increased communication with another leads to greater trust. Increased trust leads to more confidence in the relationship. And do you know about the 48 hour rule? Or as I call it - the still waters rule? If a person or a partner does something that makes you upset/ruffles your waters, you need to tell them about it. But you don't have to do so right away. If you're still upset or hurt **48 hours** later, say something. If not, just return to still waters.

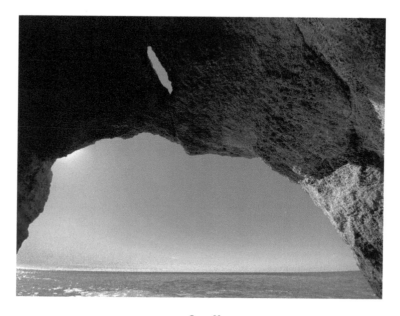

Open Up

Pondering And Penning

Open Up

See The Span/Live The Span: Along Still Waters

The span of something is the total breadth/width of that something from one end to the other. Life span is what readily comes to mind when I give thought to span. While you can't control your genes, *you can make a difference in how well you live.* As I peered at this photograph with a backdrop of still waters, it seemed to stretch from one end of the horizon to the other with a lot of light in between. And I decided that is how I want my life to be lived fully, from one end to the other with lots of light in between. That doesn't mean that all of life is rose-colored, but what it does mean is that I can control the amount of light by my daily choices and my daily mindset. I believe in that old saying "attitude is everything." And in this case, I mean a positive attitude and positive thinking. A positive mental attitude sees the good and the accomplishments in your life, rather than the negative and the failures. A positive attitude is a mindset that helps you see and recognize opportunities. What type of attitude do you choose in your daily life? What type of day to day mindsets do you foster? Do you want to see the span and live the span (with optimism)? For whatever it is worth, it might just determine a great deal of still waters or rough waters as you travel along your life's span. *Remember, YOU can make a difference in how well you live!*

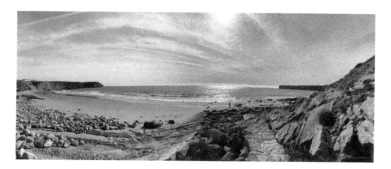

See The Span/Live The Span

Pondering And Penning

See The Span/Live The Span

Cloud Power: Above Still Waters

It's no secret that moods change with the weather. Over the years, there have been numerous studies on how weather and climate impact our moods and overall quality of life. Just recently, a new study by a team of American and Canadian researchers found a strong link between certain weather conditions and people's moods as expressed through their social media postings. Oh boy, what next? But there is a true science of cloud power as well as the emotional power of clouds - how they speak to us and how they affect our frame of mind. Personally, I like to look beyond the cloud itself and imagine what's inside. Going beyond the naked eye and going inside reminds me of the quote by Ralph Waldo Emerson that states "What lies behind us and what lies before us are tiny matters compared to what lies within us." So, when I peer at the clouds, I begin to go inward. I seek and ponder on the power of what's inside me and I create my own cloud power. Who and what determines your cloud power?

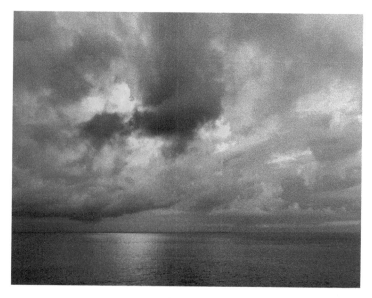

Cloud Power

Pondering And Penning

Cloud Power

A Still Life: And Still Waters

2020-21 will certainly be remembered by many as "The COVID years." In fact, they say that Generation Alpha (born 2011-2025) will forever be defined by these two tumultuous years. However, I, too, as a Baby Boomer (1946-64) have been forever changed as a result of the pandemic. I have, for example, spent more time at my computer than ever; purchased more merchandise online than ever; been more alone than ever; (probably eaten more than ever); and yet I have had some very enlightening and exhilarating moments. In fact, one of those times was an impromptu, spur of the moment drive to Moab, Utah. Upon arrival, I checked into a Marriot, unpacked my bags and headed out for a what I hoped would be day of solace and as good fortune would have it, my first view was a beautiful riverscape, a picture perfect riverscape. So, out came my camera, out came my journal and then came the luxury of stillness and a perfect day for pondering. After all, isn't that what a "Still Life" and "Still Waters" are for?

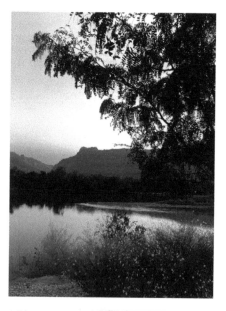

A Still Life

Pondering And Penning

A Still Life

Be A Keeper And A Wickie: Amidst Still Waters

I want to be like a lighthouse keeper (and a wickie)! The first image that comes to mind is the keeper of the lighthouse itself. The keeper symbolizes various things, such as a person who overcomes challenges and adversity or provides guidance. The keeper is most commonly known as the person who symbolizes a way forward and helps others navigate through the world. The second image is the lighthouse wickie, the person who tends to the inside of the lighthouse. A **lighthouse** wickie is a **person** responsible for tending and caring for the light and lens, especially in the days when oil lamps and clockwork mechanisms were used. **Lighthouse** wickies not only light the wicks in lanterns and create the light, but they care for and ensure that the light is always on. I think I want to be both a keeper and a wickie ... and I think I will do it best amidst still waters!

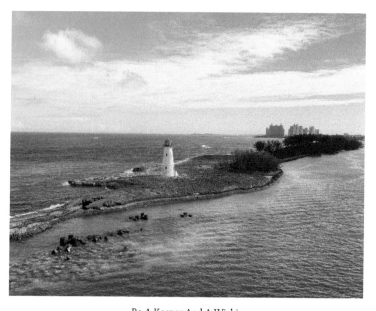

Be A Keeper And A Wickie

Pondering And Penning

Be A Keeper And A Wickie

You Are Not Alone: Beside Still Waters

"You Are Not Alone" is a phrase that is used a lot in the mental health community. But what does it really mean? I'll be honest. The first time I heard the phrase, it seemed rather like a cliche'. At this point in life, I understand this colloquial phrase better. It's not supposed to be taken literally, as in someone is right there and in your very presence. It's more of a saying that reaffirms you are a part of a community of people that have experienced similar issues and challenges. We may feel alone because we don't see a person standing beside us, but we aren't alone because there are SO many of us experiencing like circumstances. So yes, while I used to dislike the phrase "You Are Not Alone," now I have really come to embrace it, because it reminds me that I'm not the only one on this planet experiencing "this issue or circumstance." Now I realize that I am not alone and I hope you can come to that realization, too.

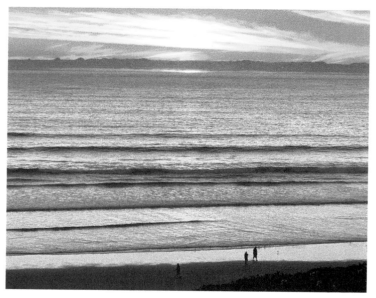

You Are Not Alone

Pondering And Penning

You Are Not Alone

A Sneak Preview: Reaching Still Waters

A *sneak preview* of something is an unofficial opportunity to have a look at it before it is officially published or shown to the public. A sneak peek is also sometimes just a "teaser" of what is to come. We continually give others sneak previews of who WE are by not only what we say but how we say it …. and with what intentions? I have learned many a life's lesson from Madeline Albright. Perhaps, the one quote that ultimately stuck states "No matter what message you are about to deliver, whether it is holding out a hand of friendship, or making clear that you disapprove of something, is the fact that the person sitting across the table is a human being, so the goal is to always establish common ground." That is the sneak preview that I hope I have gained from growing up in this world. Somehow, via my parents or my siblings, or my partner I have learned that sneak previews tell the world who you are …. so, *show them the best of who you are* on those very first sneak previews.

A Sneak Preview

Pondering And Penning

A Sneak Preview

Spread Your Wings: Along Still Waters

"Spread your wings. It's time to fly. Make the leap. Own the sky." Quote by Ms Moem. Take risks, try new things, go places you haven't gone and be willing not to know. No one can really predict to what heights you might soar until you spread your wings along still waters. And just so you know, your wings already exist, so you just need to spread them.

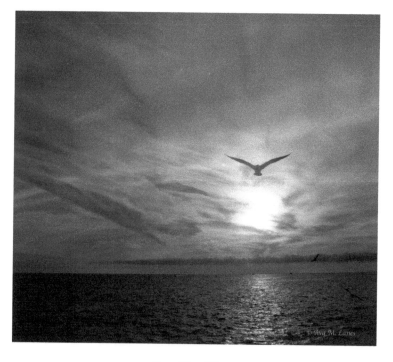

Spread Your Wings

Pondering And Penning

Spread Your Wings

There's Always A Path: In Still Waters

Imagine a path to somewhere or anywhere along still waters. Just the word itself conjures up a picture in my mind of a course or a pathway that lies in front of us, sometimes a very clear path and sometimes a blurry and distant path. But once we see it, we know there is a plan and a path for us. There's always a path!!! And it is your chosen path in life that matters. Take steps forward for yourself rather than allowing others to decide what path you should take. Yes, listen to others and take that advice in stride. But also, don't be afraid to take steps into new territories. When you stand in confidence about your decisions and actions, you will know you are headed in the right direction. Is there a right direction and a right path? The truth is and always has been, it is the journey that matters so believe in the journey and believe that there is ALWAYS a path. Allow it to unfold!!!

There's Always A Path

Pondering And Penning

There's Always A Path

Sail Simply: Along Still Waters

Warren Buffett, also known as the "Oracle of Omaha," is one of the greatest investors of our time. He's my personal favorite, not only because he's a great investor but also because he has led an exemplary life. Buffett has an unbelievable net worth. But it is Buffett's life and how he lives that has taught us many a lesson.

Below is one of the best life lessons from Warren Buffett:

Although he's so wealthy, Buffett prefers to live with simplicity and much below his means. He still lives in the home that he purchased in the 50's. Buffett has his breakfast at McDonald's and drives the same car he has had for years. This doesn't mean that he doesn't live well. He doesn't feel the need to be extravagant. Living simply will remove the pressure to impress people and focus on what matters. If you feel validated within yourself, you won't need external validation. Lesson learned **"Sail Simply ... Along Life's Still Waters."**

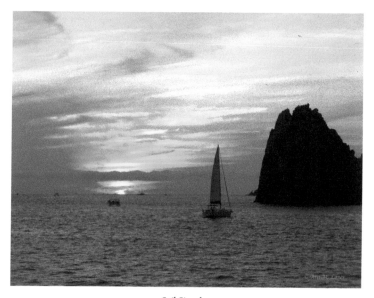

Sail Simply

Pondering And Penning

Sail Simply

The Secrets Of Whales: In Still Waters

National Geographic Magazine continues to venture deep into the world of whales. The upcoming original series, *Secrets of the Whales,* unveils the new science and technology to spotlight whales as they make lifelong friendships, teach clan heritage and traditions to their young, and grieve deeply for the loss of loved ones. Filmed over three years in 24 global locations, throughout this epic journey we learn that whales are far more complex and more like us than ever imagined. Personally, anytime I have been fortunate to get a glimpse of a whale, I am truly ecstatic! Never once, have I said – "oh, that's just another whale." In fact, I marvel at them and am convinced that we as humans have much to learn from them. We do need to continue to learn how to foster lifelong friendships and we do need to preserve our heritage and we do need to teach traditions to our young. The playbook has already been written and now the secret is …. how can we learn from whales and how can we become more like them?

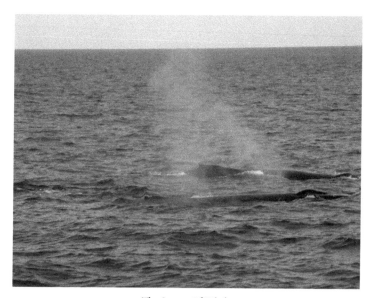

The Secrets Of Whales

Pondering And Penning

The Secrets Of Whales

A Parachute: Above Still Waters

There are an endless amounts of reasons as to why someone would choose to parachute out of a perfectly good airplane …. and god knows, why they would do it above a body of water? Is it mostly for the freedom or for the thrill? Is it to find a sense of belonging with a small community filled with people like them? Or can it be used as a form of therapy, to clear the mind and create positive emotions? Or is it, maybe, as simple as crossing it off the proverbial bucket list? Some say parachuting is very much a mental game of overcoming fear and battling with your sense of judgement. Many others say it is simply good for your mind and your soul …. a chance to fly, a change to glide, an opportunity to feel freedom and a time to experience a new view of the world. I am not saying you have to parachute, but what I am saying is that your body and mind need to experience the exciting aspects that come with doing something you have never done before. So, I fondly say "open your parachute" or at the very least, do something that is renewing and revitalizing!!!

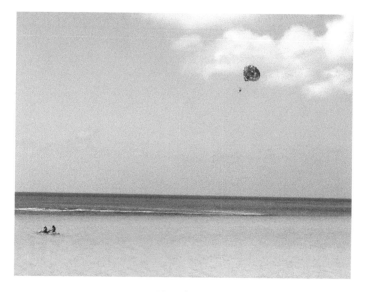

A Parachute

Pondering And Penning

A Parachute

Double Take: Along Still Waters

Ever had a delayed reaction or a double take? I have often had the need to look at something again, either because I didn't pay enough attention the first time or I was just plain intrigued with what I saw. The still waters, adorned with monolithic rocks, along the beaches of Oregon, have always been a source of fascination for me. For all of us, we often become pre-occupied and self-absorbed in the chores and "to do" tasks of daily life. The next time you are along the beaches of Oregon or find yourself simply sitting near a body of water, **do not move a muscle** …. just do a double take and peer into the forces of nature …. go to your innermost self. Be at peace, be thankful, count those blessings and be sensitive to that fact that a double take moment is a gift in one's life!

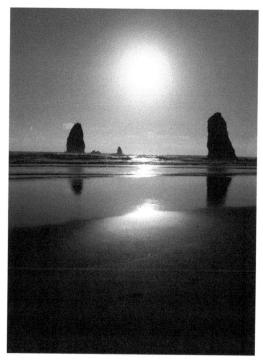

Double Take

Pondering And Penning

Double Take

Your "Seagull" View: Of Still Waters

Ever wish you were a bird just gliding above still waters OR a seagull perched on the beach, gazing at the body of water that lies in front of you? What is that seagull thinking, you might ask. What view do they have? One of simplicity or one of complexity? Seagulls are clever. Seagulls learn, remember and even pass on behaviors, such as stamping their feet in a group to imitate rainfall and trick earthworms into coming to the surface. In Native American symbolism, the seagull represents a carefree attitude, versatility, and freedom. And although we may never know a seagull's thoughts, we can deeply appreciate the field of vision and the perspective they must have when peering at still waters. We, too, can gain perspective just by being still, by having a deep appreciation of what lies in front of us, and by relishing nature to the fullest. So, just imagine you are that seagull, muse in your own thoughts and just appreciate that view that lies before you.

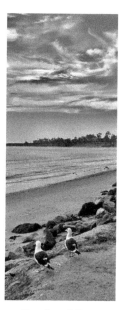

Your Seagull View

Pondering And Penning

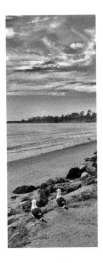

Your "Seagull" View

Gen C: Cruise Into New & Still Waters

I am writing this paragraph to introduce you to the seven living generations of Americans: **The Greatest Generation** (born 1901-27), **The Silent Generation** (born 1928-45), **Baby Boomers** (born 1946-64), **Generation X** (born 1965-80), **Millennials** (born 1981-97), **Generation Z** (born 1998-2010), and the burgeoning **Generation Alpha** (born 2011-25). And then there is an another label entitled Gen C. Gen C is a powerful new force in consumer culture. It's a term we use to describe people who care deeply about creation, curation, connection, and community. It's not an age group; it's an attitude and mindset defined by key characteristics. Even though I am a Baby Boomer by birth, I consider myself a Gen C, or the very least, I want to be a Gen C. I feel as if I have, with age, cultivated those characteristics and flourished. To be honest, to date I feel somewhat ageless. So what generation are you? Do you fit the descriptors of your generation's label (just google it)? No matter the case, break out!! YOU do not have to be defined as age group, and you, too, can possess the attitudes and mindsets of a Gen C'er.

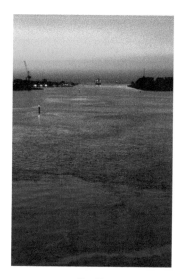

Gen C

Pondering And Penning

Gen C

Leave Your Footprints Or Your Shoes: Along Still Waters

Because of the sand on the beach, we can all leave footprints. Some footprints leave a deeper mark in the sand only because some people tell a more powerful story than others. When I think of leaving imprints, in some ways, it makes my soul and my shoes dance and I want your soul and your shoes to dance, too. Try to write your own story, one that lingers so others might re-tell it and walk in your shoes. For me, I want to write the story of kindness. Being kind is a way of living that keeps giving long after the kind thoughts, words, and actions have taken place. Kindness is a force without force, and it goes well beyond manners to the very heart of how people respect and treat one another. Being kind is a vital way of making our own lives, and the lives of others, meaningful. Being kind allows us to communicate better with others, to be more self-compassionate, and to be a positive person. What is the story you want to write? What is the imprint you want to leave? And as you write your story and make your future footprint(s), does it make your soul and your shoes want to dance?

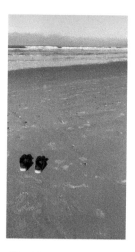

Leave Your Footprint Or Your Shoes

Pondering And Penning

Leave Your Footprints
Or Your Shoes

CPSIA information can be obtained
at www.ICGtesting.com
Printed in the USA
BVHW061522020721
611053BV00022B/1682